Dedication

I dedicate this book my bonus daughter Gabriella. I hope she keeps her creative side alive always. Love you always.
~Twigs Greenpage

Copyright 2019.
Please look for more coloring books, activity books, journals, planners and notebooks on the Amazon Marketplace.
To view our Author page go to:
 amazon.com/author/twigsgreenpage
Follows us on Facebook at:
www.facebook.com/twigsgreenpage/
Check out our Coloring group on facebook where you can post any and all colorings you complete!
Color Addicts by Twigs Greenpage

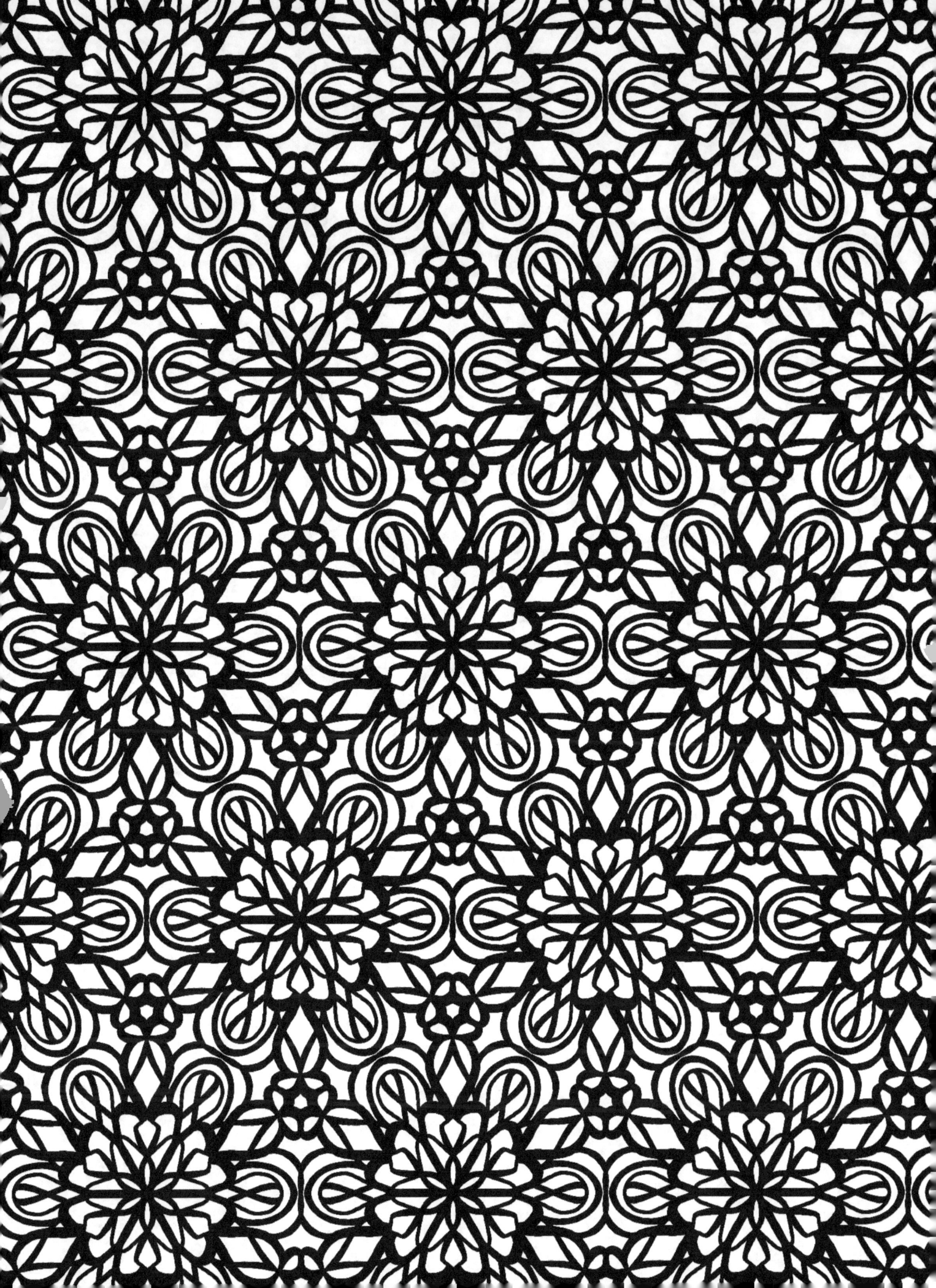

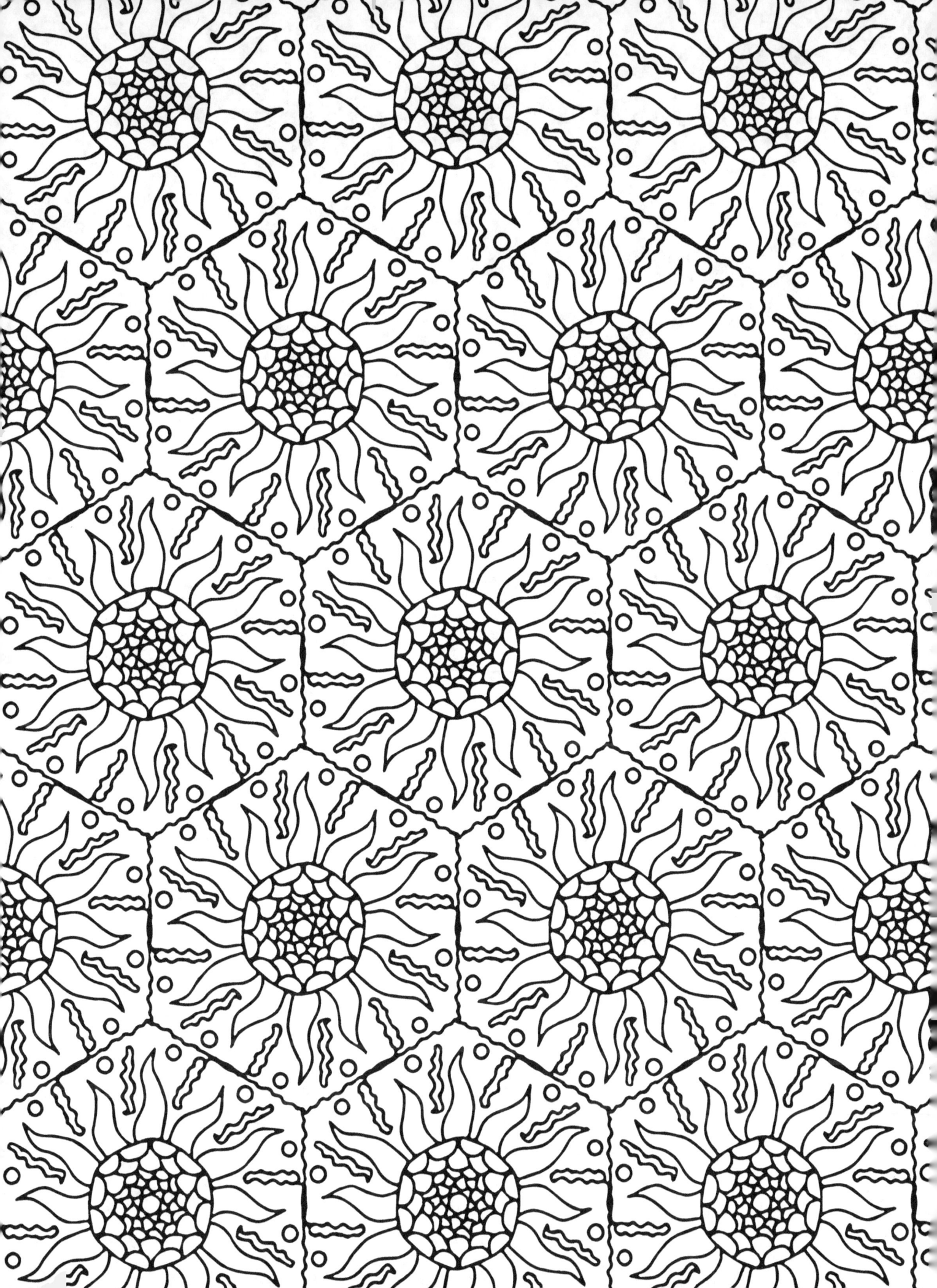

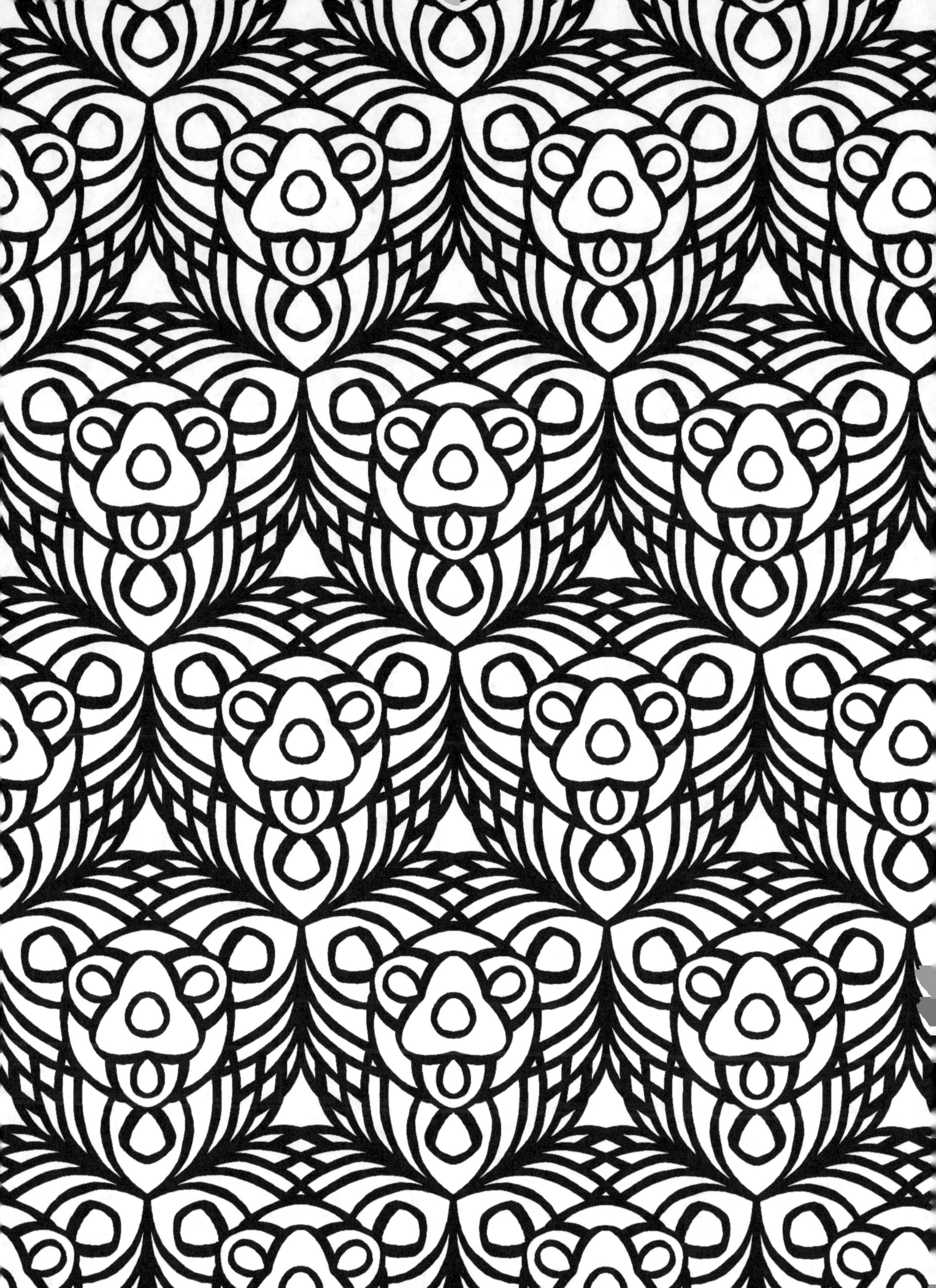

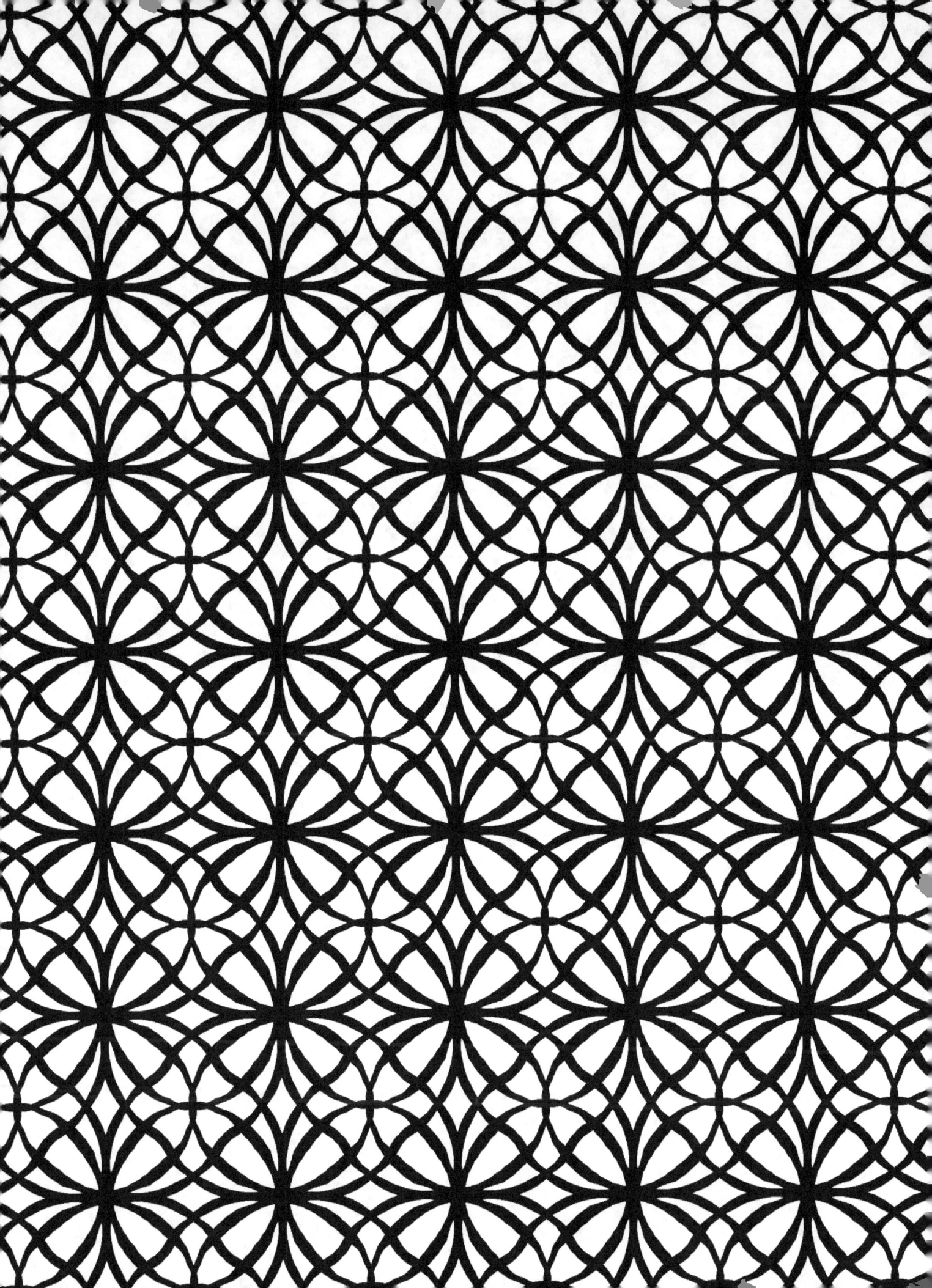

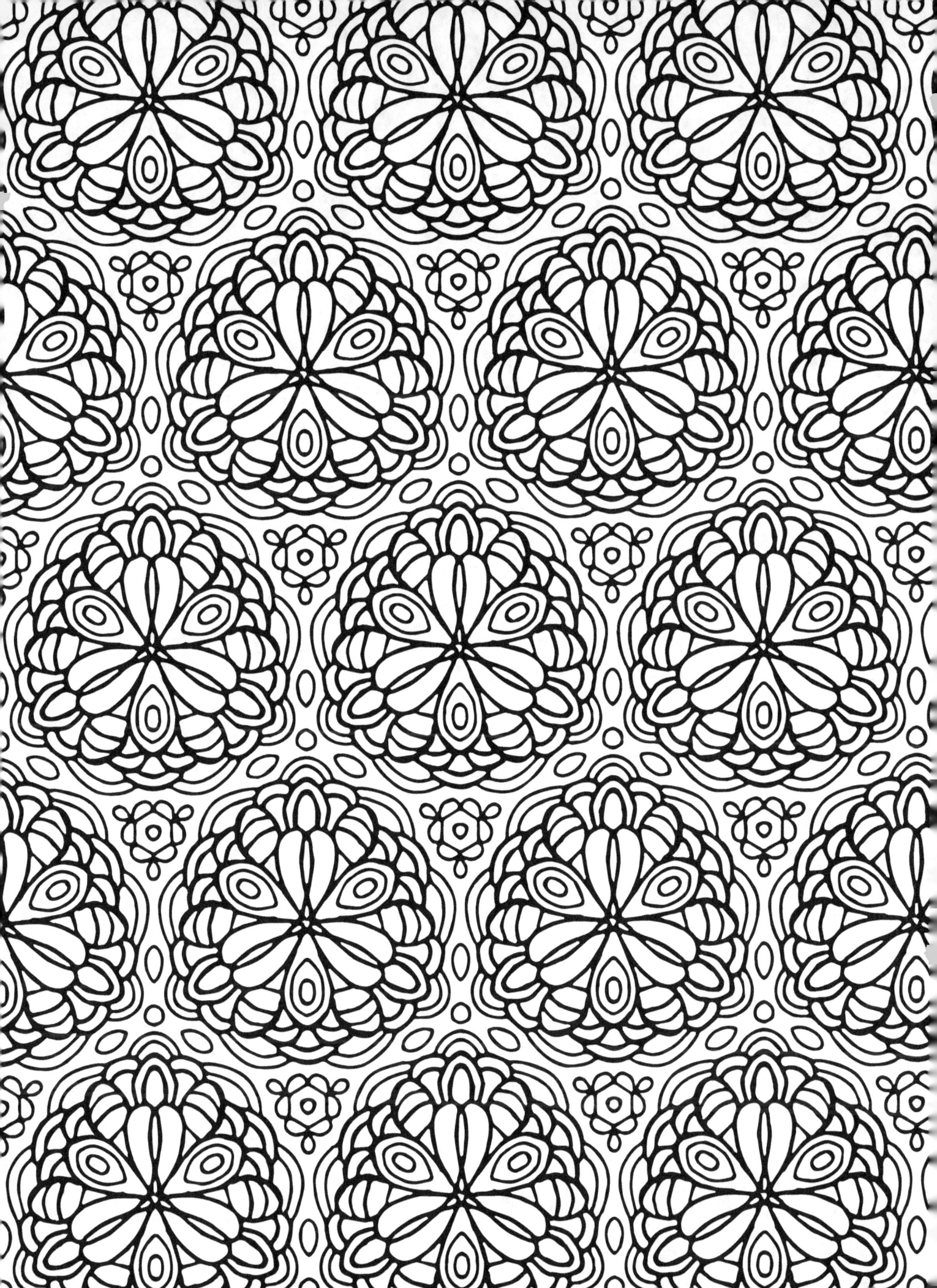

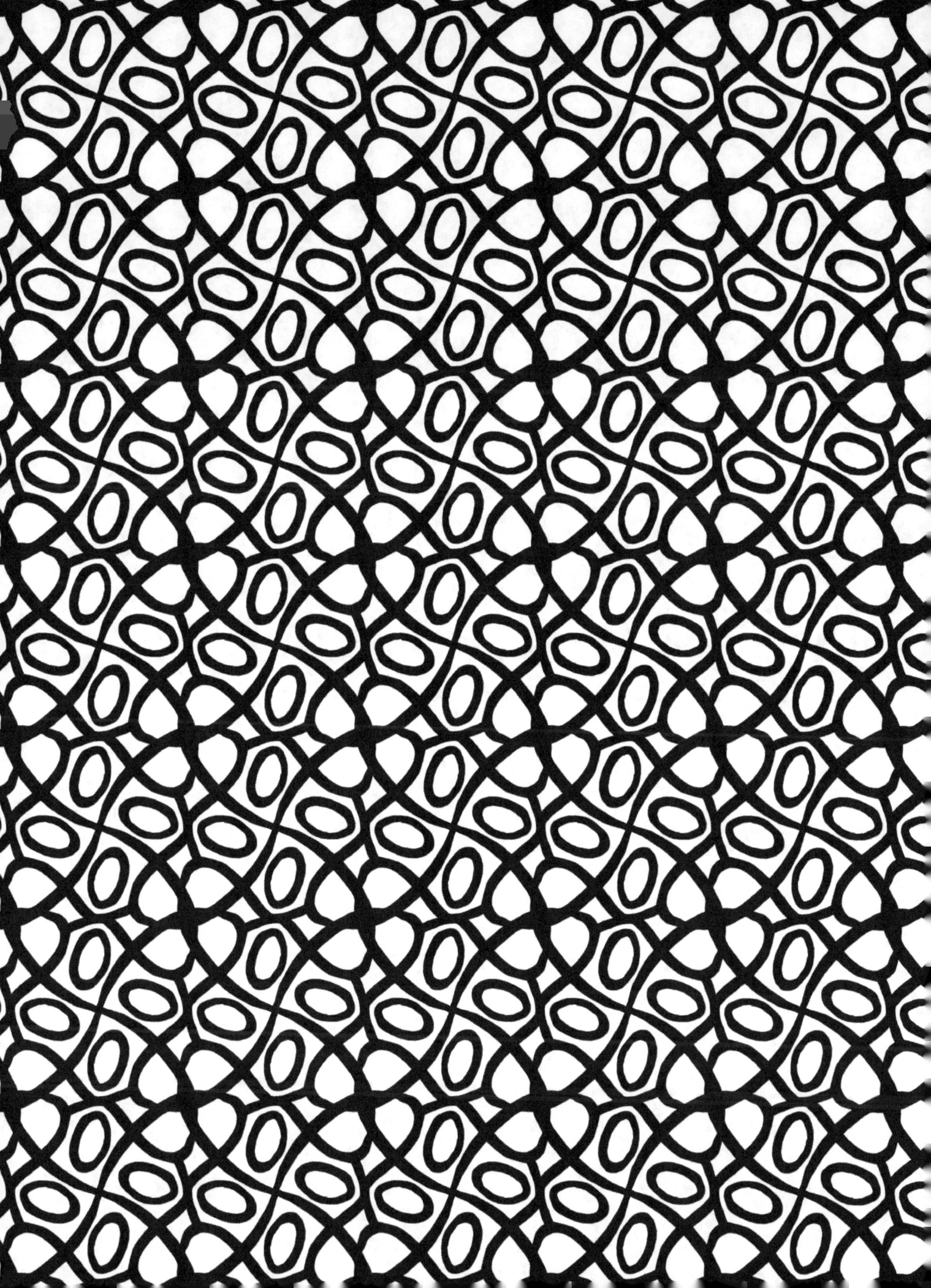

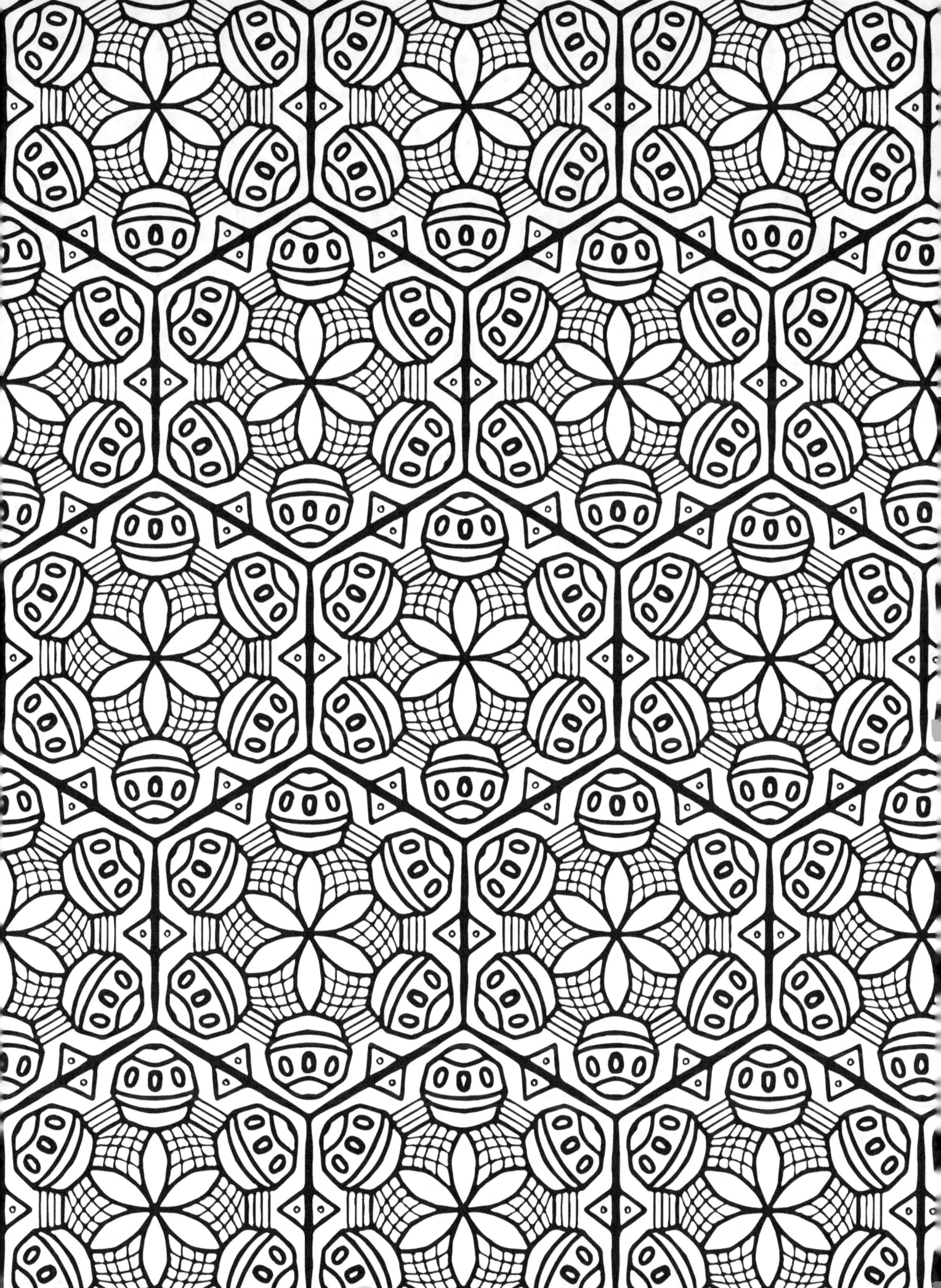

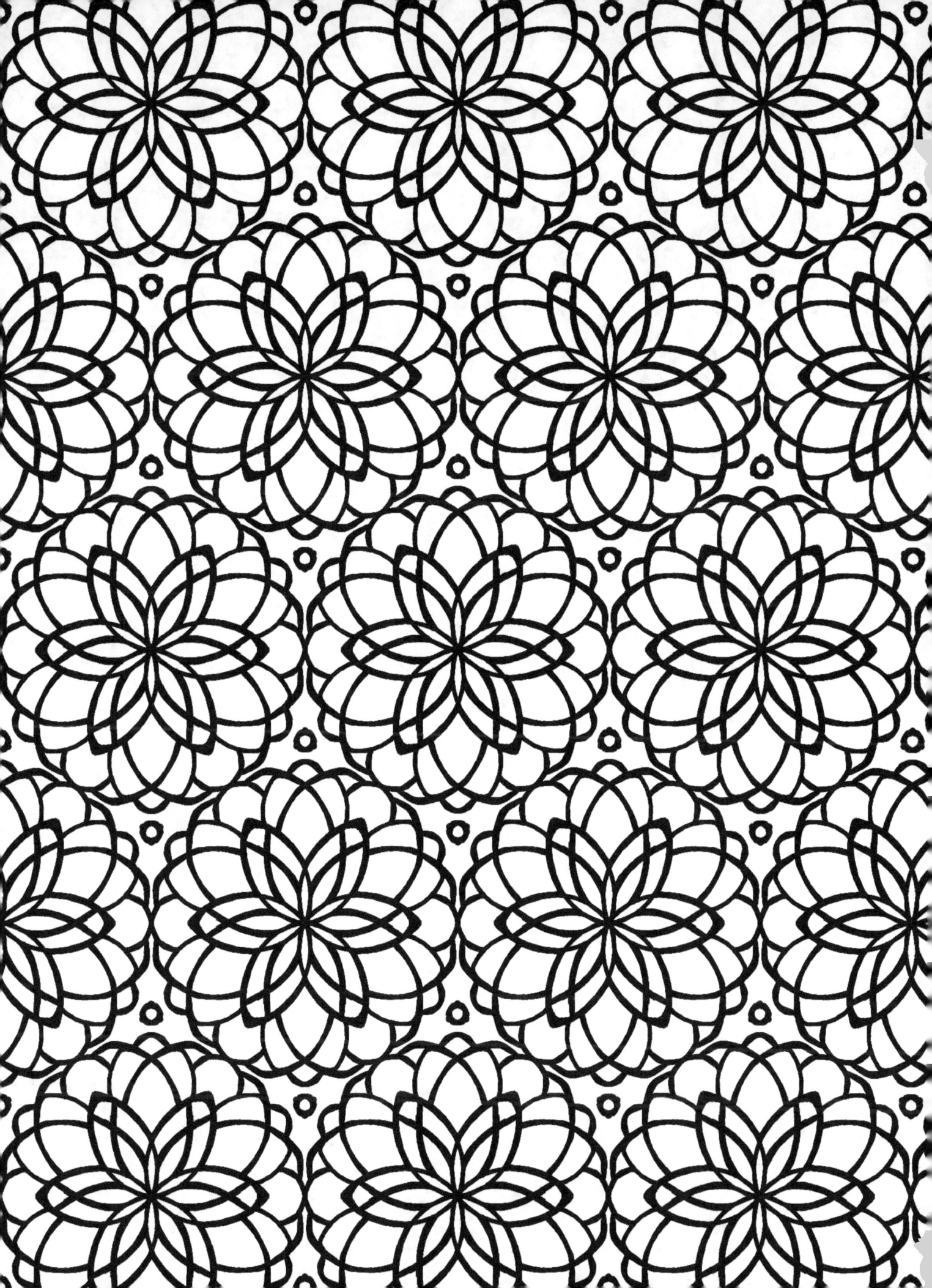

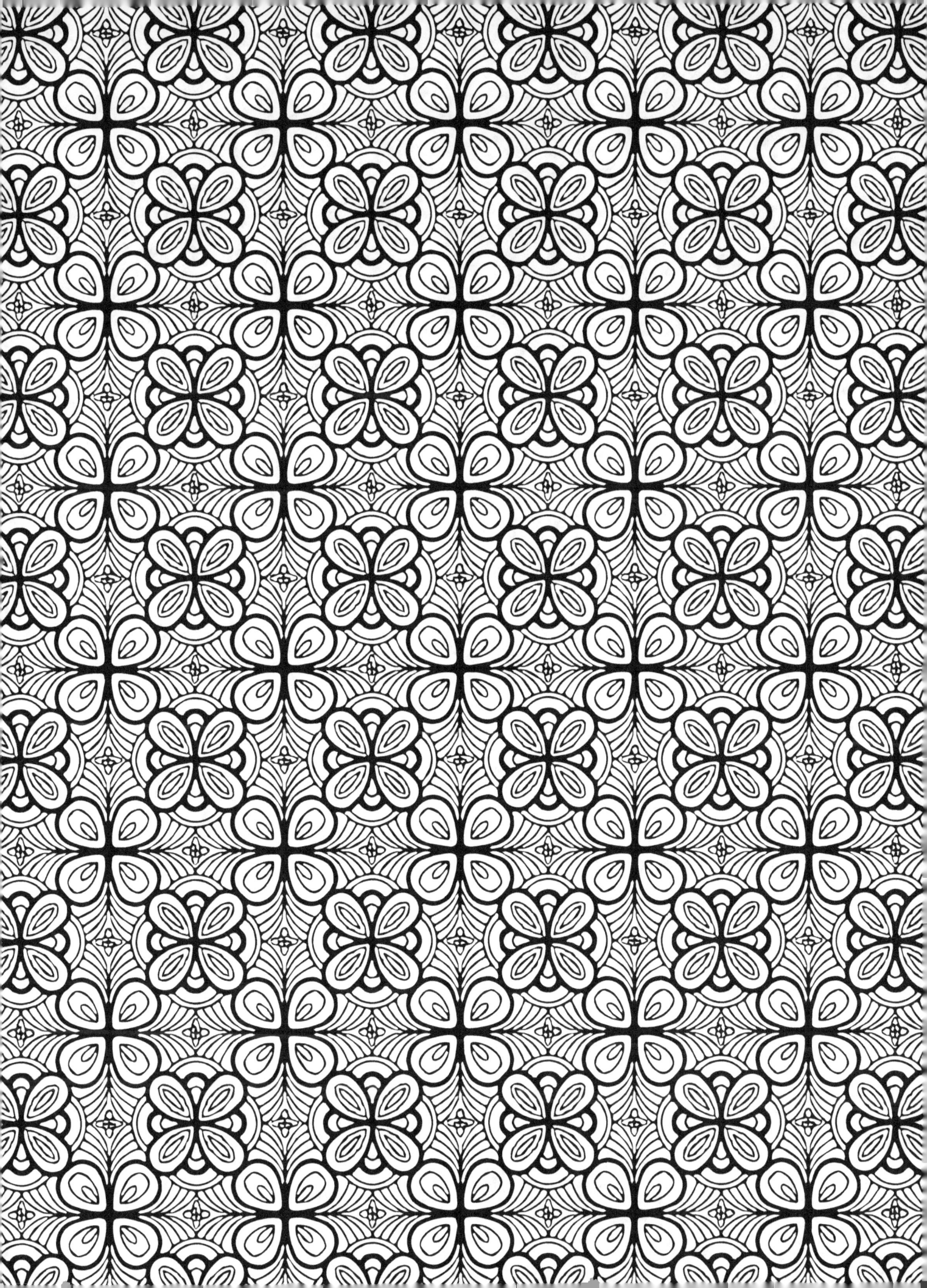

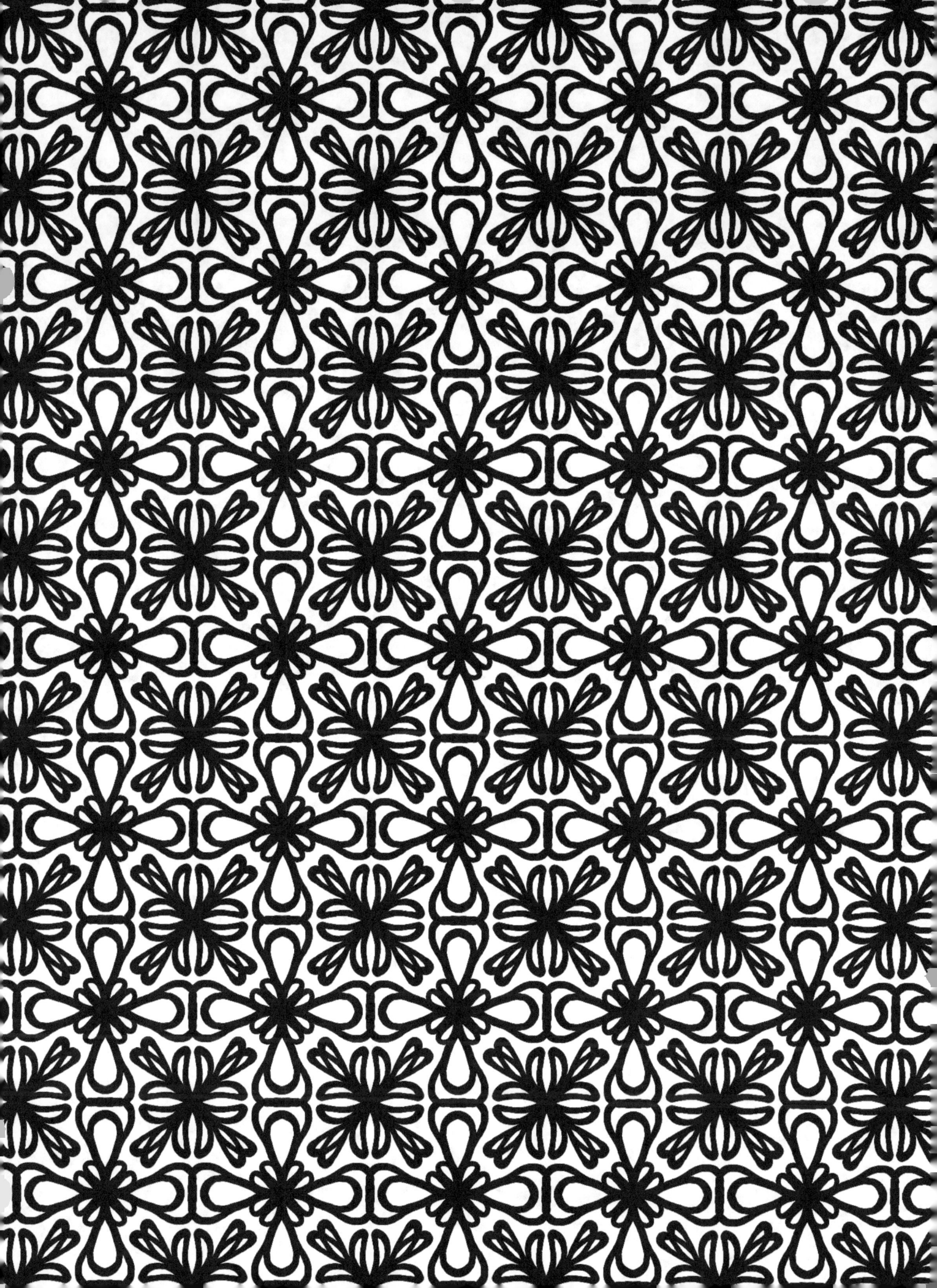

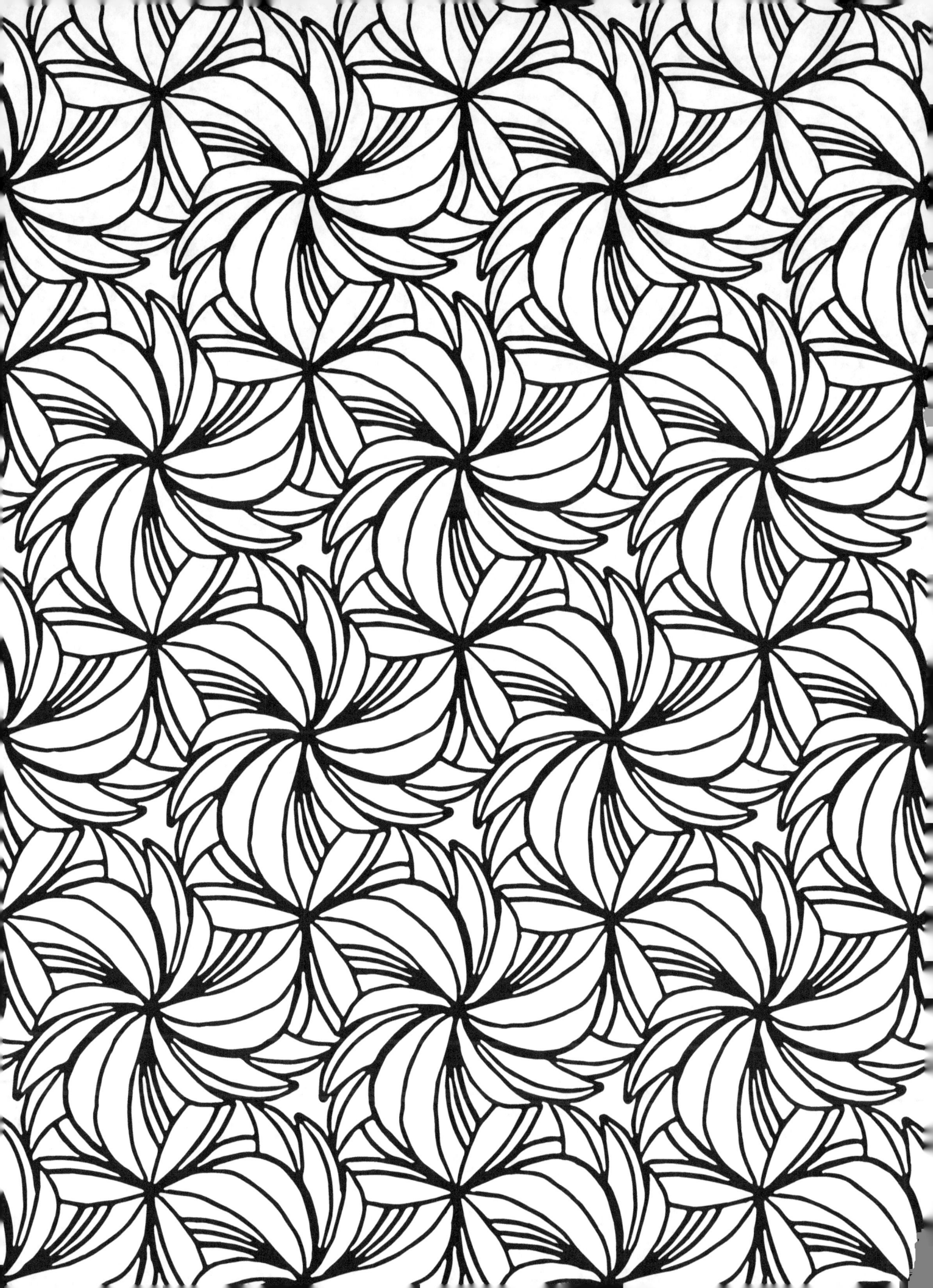

Other titles by Twigs Greenpage

<u>Coloring books</u>
Accessible Coloring Book
Hummingbird Humor Coloring Book
Scardy Pardy and Friends - Boston Terrier Coloring Book
Ellis Island Gateway to Freedom Coloring Book
The Beatz Sweets Farm Coloring Book
Nature Mandala Coloring Book
Zen as Fuck: A Cussing Coloring Book
Halloween Mandala Coloring Book
52 Ways to Find Your Smile Coloring Challenge
52 Ways to Find Your Smile Through Coloring and Journaling
Dracula A Blood Sucking Coloring Book
Pretty Patterns Adult Coloring Book Vol. 1

<u>Prompt Journals</u>
Zen as F*ck
What's up Monkey Butt
Today We Garden
30 Day Drawing Challenge Journal
Escape Room Tracker: Scrapbook

<u>ADHD Resources</u>
Daily Behavior Report Card
Keep Calm and Start Doing
My ADHD Adventure
Code of Conduct

Doodle Notebooks
Dot Grid Journals
Bullet Planners

Many Blank Journals and Notebooks are available as well.
Copyright 2019 Twigs Greenpage

www.ingramcontent.com/pod-product-compliance
Lightning Source LLC
Chambersburg PA
CBHW081658220526

45466CB00009B/2807